# NORTH MICHIGAN AVENUE

## A BUILDING BOOK FROM THE CHICAGO HISTORICAL SOCIETY

JOHN W. STAMPER

*Pomegranate*

SAN FRANCISCO

Published by Pomegranate Communications, Inc.
Box 808022, Petaluma, CA 94975
800 227 1428; www.pomegranate.com

Pomegranate Europe Ltd.
Unit 1, Heathcote Business Centre, Hurlbutt Road
Warwick, Warwickshire CV34 6TD, UK
[+44] 0 1926 430111; sales@pomeurope.co.uk

Library of Congress  Control Number: 2005903916

Pomegranate Catalog No. A104

Cover and book design by Lynn Bell, Monroe Street Studios, Santa Rosa CA

Printed in Korea

14 13 12 11 10 09 08 07 06 05   10 9 8 7 6 5 4 3 2 1

## Mission

The Chicago Historical Society collects,
exhibits, and interprets documents, images,
and artifacts related to the history of the
United States and metropolitan Chicago.

Its mission is:

- To expand audiences for history
- To be a leader in history education
- To be a premier research institution

Chicago Historical Society
Clark Street at North Avenue
Chicago Illinois 60614
www.chicagohistory.org

## Acknowledgments

I would like to thank Rosemary Adams and Jordan Walker of the Publications
Department as well as Robert Medina and the staff of the Rights and
Reproduction Department at the Chicago Historical Society for their assistance
with this book. Also thanks to my wife, Erika Pistorius Stamper, for proofreading the manuscript.

# CONSTRUCTION CHRONOLOGY

*1866–1869*  Chicago Water Tower and Pumping Station, only buildings on Near North Side to survive Fire of 1871.

*1909*  Proposal for North Michigan Avenue in *Plan of Chicago*.

*1913*  Ordinance to begin Michigan Avenue Project passed, to widen Pine Street and build Michigan Avenue Bridge.

*1918–1920*  North Michigan Avenue Bridge.

*1919–1920*  Drake Hotel; John Crerar Library (demolished 1983); Italian Court Building.

*1920–1924*  Wrigley Building, first major office building built outside the Loop on north side of river. North Central Business District Association's (NCBDA) master plan published.

*1921–1922*  Palmer Shops Building (demolished 1989); Lake Shore Trust and Savings (First National Bank of Chicago).

*1922–1925*  Chicago Tribune Tower; London Guarantee and Accident Building.

*1923–1924*  Allerton Hotel (Crowne Plaza Hotel).

*1924*  Bell Building (Old Republic Building); Michigan-Ohio Building.

*1925–1927*  900 North Michigan Avenue Apartment Building (demolished 1988).

*1926–1927*  Lake-Michigan Building (Harvester Building); Farwell Building; Women's Chicago Athletic Club.

*1927–1928*  Medinah Club (Hotel Inter-Continental); 333 North Michigan Avenue Building; Palmolive Building (Landmark Residences); Michigan-Chestnut Building (demolished 1992).

1928–1929   Erskine-Danforth Building; Michigan Square Building (demolished 1978); McGraw-Hill Building (Le Meridien Hotel/Nordstrom Department Store); Michigan-Chestnut Building (demolished 1992); Michigan-Superior Building (demolished 1986).

1929   Union Carbide and Carbon Building (Hard Rock Hotel).

1947   Rubloff Plan for the Magnificent Mile made public.

1961–1965   Equitable Building.

1965–1970   John Hancock Building.

1968–1970   Illinois Center.

1971   625 North Michigan Avenue.

1974–1976   Water Tower Place.

1983   Associates Building (Smurfit-Stone Building) 150 North Michigan Avenue, in place of Crerar Library; One Magnificent Mile; Neiman Marcus Building.

1989   900 North Michigan Avenue, where 900 North Michigan Avenue Apartment Building had been.

1990   City Place; Chicago Place.

1996   600 North Michigan Avenue, replaces Michigan-Ohio and Erskine-Danforth buildings.

1997   Pottery Barn (Peninsula Hotel block).

2000   Park Tower, home to Park Hyatt Chicago Hotel.

2001   Nordstrom Department Store; McGraw-Hill Building converted to Le Meridien Hotel.

# INTRODUCTION

North Michigan Avenue is famous worldwide as Chicago's preeminent shopping, hotel, and office thoroughfare. Its wide, boulevard-like appearance, with tree-lined sidewalks and magnificent architecture, makes it one of the country's most memorable urban sites and tourist destinations. The planning and development of North Michigan Avenue date to the work of one of Chicago's most notable architects: Daniel H. Burnham. In his 1909 *Plan of Chicago,* he proposed extending Michigan Avenue from the Chicago River to Oak Street, to make it the principal thoroughfare linking the Loop with the rapidly growing north side.

The buildings lining the avenue range from Beaux Arts Classicism and Gothic Revival to Art Deco and International style, designed by many of the country's leading architects, including Raymond Hood, Ralph Adams Cram, Holabird and Root, and the firms of Graham, Anderson, Probst and White and Skidmore, Owings and Merrill. Two slight turns in the avenue's path—one at the bridge and one at the historic Water Tower—visually enhance and define the urban corridor by creating axial views to major architectural monuments: the Wrigley Building, Tribune Tower, the Water Tower, and the 333 North Michigan Avenue Building.

The first critical period of the avenue's development occurred between 1900 and 1930 when the bridge was constructed, the former Pine Street was

Chicago Historical Society, photograph
by Sigmund J. Osty, ICHi-38624

View of North Michigan Avenue looking north, the Wrigley Building on the left and the Tribune Tower to the right. Michigan Avenue makes a slight shift in its axis at the bridge plaza, creating a dramatic view, with the John Hancock Tower in the distant background.

widened, and most of the blocks fronting the avenue were developed with new mid- or high-rise buildings. The Great Depression and the following war years interrupted its development, which resumed in the 1960s with a renewed building boom that added several new landmark skyscrapers to Chicago's skyline. Throughout its history, Michigan Avenue has benefited from its property owners and developers maintaining a high quality of land use and architecture. But this emphasis on quality design and fashionable commercial activity has brought crowded sidewalks, congested automobile traffic, and over-commercialization, and the subsequent destruction of several notable buildings constructed in the 1920s has led to much controversy. The North Michigan Avenue remains, however, one of Chicago's most vital streets and popular tourist attractions.

## Early Development

The Michigan Avenue Bridge is the site of Fort Dearborn and the log house of the city's first settler in the eighteenth century, John Baptiste Pointe du Sable. As Chicago grew into a thriving town during the 1850s and 1860s, Michigan Avenue south of the river became built up with stores and warehouses, all directly overlooking Lake Michigan. The area immediately north of the river similarly became crowded with warehouses and factories; the blocks farther north were lined with residences and townhouses. Michigan Avenue then extended only as far as the Chicago River. From there, an iron bridge that

angled to the northwest carried traffic to
Rush Street, a busy north side commercial
and residential street.

The Great Fire of 1871, which destroyed
the entire downtown, also destroyed the
area along the river, and up the North Side
as far as Lincoln Park. The only structures
on Pine Street undamaged were the Water

Tower and Pumping Station. As Chicago rebuilt itself, Michigan Avenue at the
river continued to be the site of wholesale and industrial buildings, merchants
taking advantage of the riverfront access for shipping and receiving.  The area
to the north, from Grand Avenue to Chicago Avenue, became known as
McCormickville, site of large mansions of many of Chicago's great industrialists.

North of McCormickville, the area around the Water Tower and Pumping
Station became known as Streeterville, after the itinerant Captain George
Streeter, whose boat *Reutan* became stranded on a sandbar off the end of
Superior Street in 1886. He kept his boat there for several years while claiming
responsibility for an extensive landfill project north and east of the Water
Tower, actually carried out by the Lincoln Park Board and the contractor,
Charles Fitzsimons. One of the oldest remaining buildings from the
Streeterville era is the Fourth Presbyterian Church, one of the finest neo-
Gothic churches in the city, featuring an arcaded cloister and a brilliantly

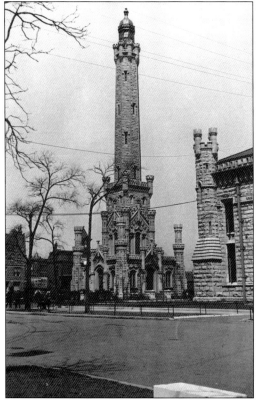

Chicago Water Tower and Pumping Station, North Michigan Avenue at Chicago Avenue, 1866–1869, William W. Boyington, architect. These were the only buildings on the Near North Side to survive the Fire of 1871. The distinctive crenellated Gothic style is one of the most picturesque in Chicago's history.

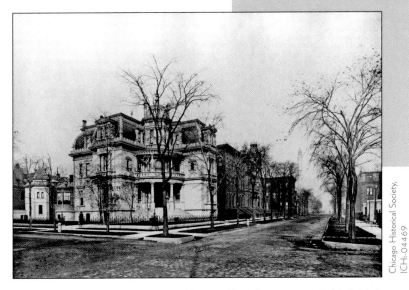

Perry H. Smith House, corner of Pine and Huron Streets, 1887, G. H. Gilsdorf,
architect. The Second Empire house was representative of the single-family residences built
in McCormickville. It was demolished when Pine Street was widened in the 1910s.

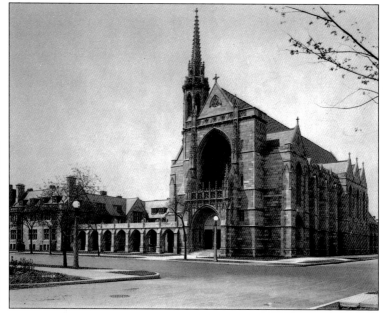

Fourth Presbyterian Church, southwest corner of North Michigan Avenue and
Delaware Place, 1912–1914, Ralph Adams Cram in association with Howard
Van Doren Shaw, architects. Cram was the most notable architect in the country
working in the Gothic style, having designed the US Military Academy at West
Point and completed St. John the Divine Cathedral in New York City.

crafted nave with a wood beam ceiling and stained glass windows.

The widening of the avenue and the construction of the new bridge were carried out from 1912 to 1920. Numerous proposals had been made since the 1890s to construct a new bridge that would continue Michigan Avenue across the river, following the path of Pine Street. Not until 1904 did the Chicago City Council take the lead in planning the new boulevard link by voting to make it an official city improvement project. It gained widespread public support with the publication of Daniel Burnham and planner/architect Edward H. Bennett's *Plan of Chicago.*

In developing this comprehensive city plan, Burnham drew on his experiences with the 1893 World's Columbian Exposition and his knowledge of European cities, particularly Rome, Vienna, and Paris. Most influential to Burnham was the city planning work of Georges Haussmann in Paris for Napoleon III, which was carried out during the 1850s and 1860s. The grand boulevard and the axial pattern of urban streets with squares and circles expressed a sense of rationalism and man's power and control analogous to that of business and industry. A rendering for Burnham's proposal for Michigan Avenue was included in the *Plan of Chicago;* it showed a broad

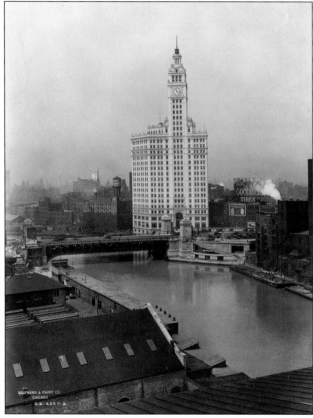

North Michigan Avenue Bridge, 1918–1920, Thomas G. Pihlfeldt, engineer, Edward H. Bennett, architect. This was the first double-deck bascule bridge constructed in Chicago.

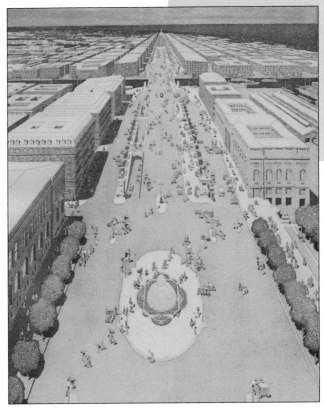

Aerial view of North Michigan Avenue, from the *Plan of Chicago*, 1909. The view is looking toward Michigan Avenue Bridge from Randolph Street; the Chicago Public Library at the left. Rendering by Jules Guerin. The character and form of this urban scene were modeled after the Champs-Elysées in Paris.

boulevard flanked by buildings of uniform height and was compared to a bird's-eye view of the Champs-Elysées.

## BUILDING BOOM OF THE 1920S

Among the first structures erected on the newly created avenue were the Wrigley Building on the northwest corner of the bridge plaza, the Drake Hotel overlooking the lakefront at Oak Street, and the John Crerar Library at the corner of Michigan Avenue and Randolph Street, overlooking Grant Park. All three buildings represented a commitment to high-quality design, construction, and urban character, hallmarks in the avenue's development for years to come. Their designs referenced popular historical architectural styles—Spanish Renaissance, Italian Renaissance, and neo-Gothic—while incorporating steel-frame structures, elevators, and modern mechanical systems for heating and electrical services.

These buildings' designs also responded to the avenue's master plan study by the North Central Business District Association (NCBDA) in 1918. Composed primarily of property owners along North Michigan Avenue, NCBDA invited a number of architects to make recommendations regarding the treatment best suited for establishing the character of the avenue's architecture. It was intended that standards for architectural design go hand in hand with restrictions as to the kinds of businesses for which the buildings could be used.

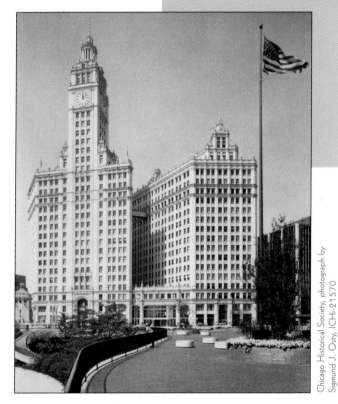

Chicago Historical Society, photograph by
Sigmund J. Osty, ICHi-21570

Wrigley Building, 1920–1924, Graham, Anderson, Probst and White, architects.
This was the first major commercial office building to be built outside the Loop on
the north side of the river. Its main feature is its twenty-eight-story tower, its design
based on the Woolworth Building in New York, by Cass Gilbert, and on the
Giralda Tower in Seville, Spain, built in the fourteenth century.

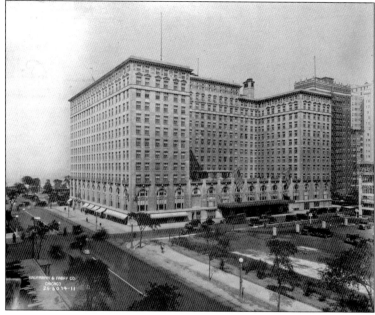

Drake Hotel, southeast corner of Michigan Avenue and Oak Street, 1919–1920, Marshall and Fox, architects. With its H-shaped plan, this building took advantage of the spectacular views of Lake Michigan, while its neo-Renaissance detailing and elaborate interior spaces set a high standard for architects of later buildings on the avenue.

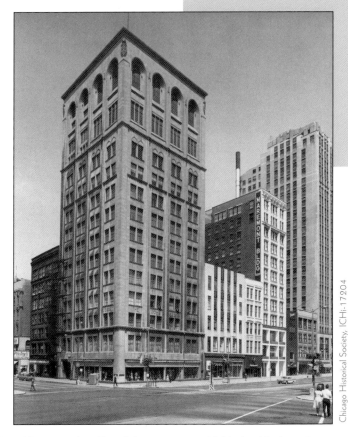

John Crerar Library, view from Grant Park, 1919–1920, Holabird and Roche, architects (demolished 1983). This building contained both offices and, on the top two floors, a research library that featured a double-height reading room overlooking Grant Park.

The architects' committee submitted its results to the NCBDA in November 1918; they were published in *The American Architect.* Among the recommendations were (1) ban uses incompatible with high-class commercial activities, (2) restrict the height of the buildings to ten stories, and (3) use a uniform, continuous balcony or cornice line between the second and third floors of each building. The recommendations generally followed Burnham and Bennett's plan for uniformity, continuous elevations, and spatial definition of the avenue, although for the bridge plaza it was proposed that high-rise buildings serve as a gateway and focal point. The goal was to make North Michigan Avenue one of the most attractive and fashionable commercial thoroughfares in the city by maintaining a high standard for architecture.

The most highly publicized building project on the avenue was the international design competition for the Chicago Tribune Tower. *Tribune* editor Colonel Robert McCormick expressed his wish of "providing an administrative building that will be an inspiration to its workers—a tower that would interpret in terms of architecture the Tribune's purpose and ideals—one that would be a model for future generations." The winning design submitted by John Mead Howells and Raymond Hood featured eight piers extending at the top, flying buttresses, and a highly decorative octagonal campanile, a design based on the thirteenth-century Tour de Beurre in Rouen, France.

While the Tribune Tower was being constructed, a third structure was designed for the bridge plaza's southwest corner: the London Guarantee

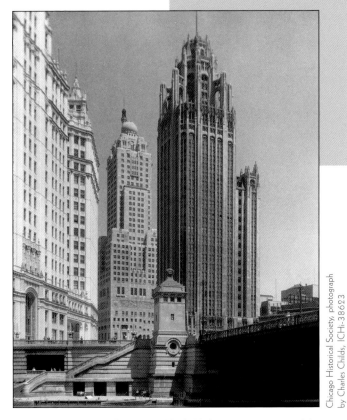

Chicago Tribune Tower, 435 North Michigan, 1922–1925, John Mead Howells and Raymond Hood, architects. The winner of an international competition, this building is like a giant church tower, with elegant buttresses, beautifully carved tracery, and an octagonal tower supported by flying buttresses.

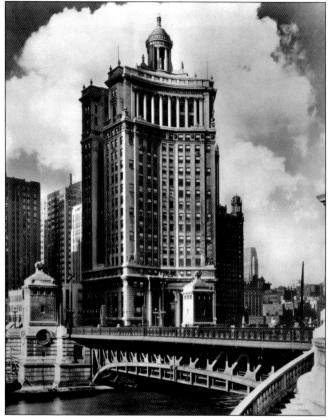

London Guarantee and Accident Building, 354 North Michigan Avenue, 1922–1924, Alfred S. Alschuler, architect. The building's owner stated that it was a great "civic" contribution to Chicago's cityscape, akin to the monuments of ancient Greece and Rome.

Building. It was built for a group of English investors and designed by Chicago architect Alfred S. Alschuler, who based his design on English Neoclassicism, with a colonnade of Corinthian columns on the main facade, a circular temple on the roof, and a triumphal arch entrance.

Other buildings followed on blocks north and south of the bridge plaza, each a more elaborate or more simplified version of the Neoclassical style. They adhered to Burnham and the NCBDA's recommendations for high-quality design, but cast aside the notion of uniform height. As the Chicago building code was stretched to allow taller and taller buildings, many developers on North Michigan Avenue saw height as a way of maximizing the return on their investment, with the added benefit of providing dramatic views of Lake Michigan. The result was a growing disparity between low-, mid-, and high-rise design, the avenue becoming a patchwork of tall skyscrapers set among variously sized smaller office and commercial buildings.

Among the skyscrapers from the mid-1920s were the Bell Building, designed by Karl Martin Vitzthum; the Lake-Michigan Building and the Michigan-Ohio Building, by Alfred Alschuler; the Allerton Hotel (now Crowne Plaza), by the firm of Murgatroyd and Ogden; and the Medinah Club (now the InterContinental Hotel), designed by Walter Alschlager.

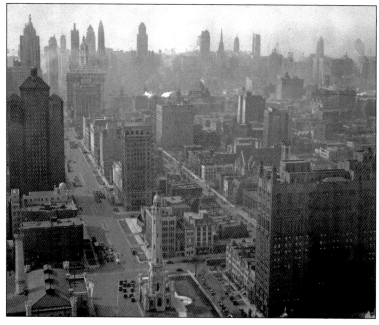

Aerial view of the avenue looking southwest, the Water Tower in the foreground. This image shows the extent to which the avenue was developed with both high- and low-rise buildings, the juxtaposition between the two quite evident.

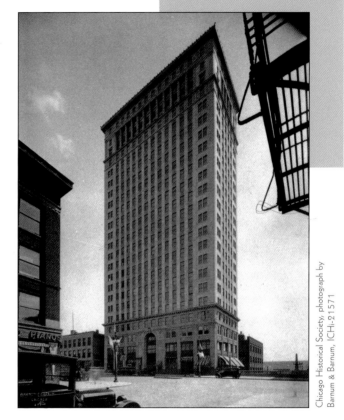

Chicago Historical Society, photograph by
Barnum & Barnum, ICHi-21571

Bell Building (Old Republic Building), 307 North Michigan Avenue, 1924,
Karl Martin Vitzthum, architect. Rising twenty-three stories, this building features a
Classical granite-clad base with Corinthian pilasters and a prominent arched entrance. Its
upper floors are clad with white terra-cotta panels similar to those on the Wrigley Building.

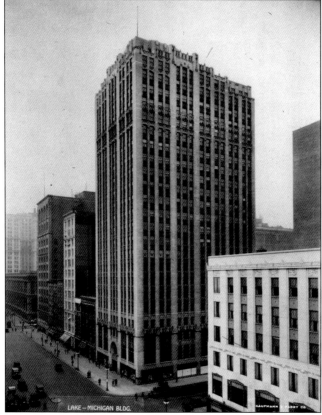

LAKE — MICHIGAN BLDG.

Lake-Michigan Building (Harvester Building), 180 North Michigan Avenue, 1926–1927, Alfred S. Alschuler, architect. The design features a strong vertical emphasis, with a stepped-back upper floor and Mayan-inspired decorative motifs.

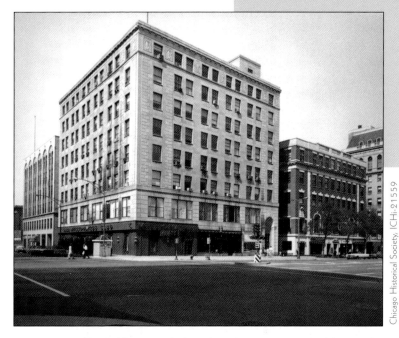

Michigan-Ohio Building, 612 North Michigan Avenue, 1924, Alfred S. Alschuler, architect; Erskine-Danforth Building, 620 North Michigan Avenue, 1928, Philip B. Maher, architect. Both these elegant Classical-style buildings (demolished 1995) were designed to conform to Burnham's 1909 design for the avenue.

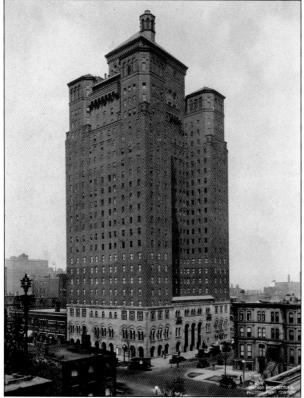

Allerton Hotel (Crowne Plaza Hotel), 701 North Michigan Avenue, 1923–1924, Murgatroyd and Ogden, architects. Part of a chain of "club hotels," the Allerton Hotel catered to young single men and women intent on pursuing professional careers. Its design was based on the medieval architecture of northern Italy.

Medinah Club (Hotel Inter-Continental), 505 North Michigan Avenue, 1927–1929, Walter Alschlager, architect. This eclectic design borrowed motifs from Egyptian, Assyrian, Persian, French, and Turkish architecture. The facade features an Assyrian-inspired sculptural relief that supposedly depicts the faces of the various people of the club involved in its construction.

In every case, the visually ornate features of the building symbolized the power of technology and of history, reflecting the belief that the use of the newly invented steel-frame technology and elevators as well as the need for a maximum return on investment did not have to mean abandonment of tradition.

Low- to mid-rise buildings included the Palmer Shops Building, by Holabird and Roche; Lake Shore Trust and Savings, by Marshall and Fox; Italian Court Building, by Robert De Golyer; Farwell Building, Women's Chicago Athletic Club, and Erskine-Danforth Building, by Philip B. Maher; and the 900 North Michigan Avenue Cooperative Apartment Building, by Jarvis Hunt.

The later years of the decade saw a gradual transition to a more modern high-rise design, followed by the influence of the sleek vertical lines and abstract ornamentation of the second-place entry in the Chicago Tribune Tower competition, submitted by Finnish architect Eliel Saarinen. This new direction in American architecture was already being formulated in New York, partly in response to that city's new zoning laws, which required stepped-back volumes, and partly by Art Deco.

The first structure on North Michigan Avenue derived from Saarinen's design was the 333 North Michigan Avenue Building by Holabird and Root, 1928–1929. Its elegant simplicity derived from a nearly complete lack of ornamentation and an emphasis on verticality; its upper stories were stepped back, their sleekness enhanced by the absence of a projecting cornice.

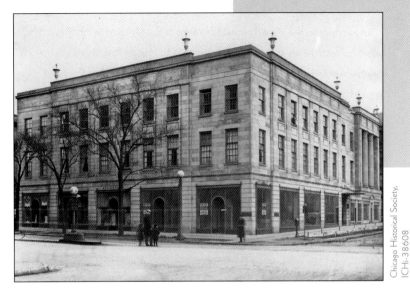

Palmer Shops Building, 942–950 North Michigan Avenue, 1921–1922, Holabird and Roche, architects (demolished 1989). This was one of the many two- and three-story buildings designed for the avenue in sharp contrast to the many high-rises. It was a model for elegant display windows and simplified Classical detailing.

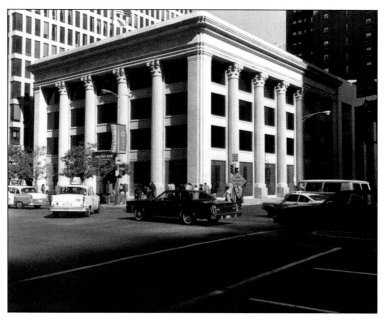

Lake Shore Trust and Savings (First National Bank of Chicago), 601
North Michigan Avenue, 1921–1922, Marshall and Fox, architects.
Modeled after a Roman temple, this building features four-story-high
Corinthian columns and a finely detailed cornice, all of Indiana limestone.

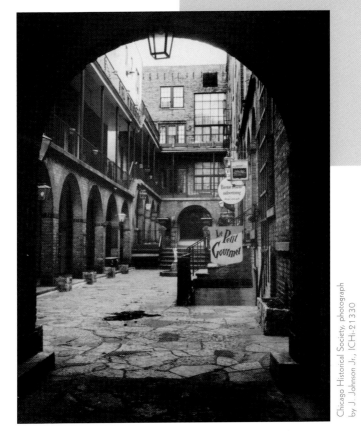

Italian Court Building, 619 North Michigan Avenue, 1919–1920, Robert De Golyer,
architect (demolished c. 1968). This charming group of buildings, occupied by residences,
studios, and elegant shops during the 1920s, included Le Petit Gourmet restaurant.

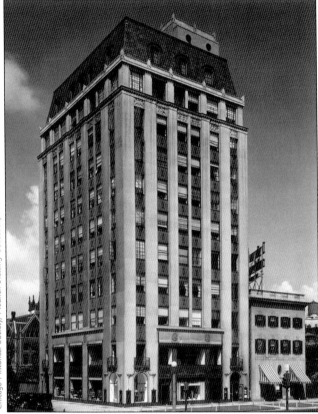

Farwell Building, 664 North Michigan Avenue, 1926–1927, Philip B. Maher, architect. With a French-inspired design, this building features elegant street-level detailing, strong vertical lines, and a mansard roof.

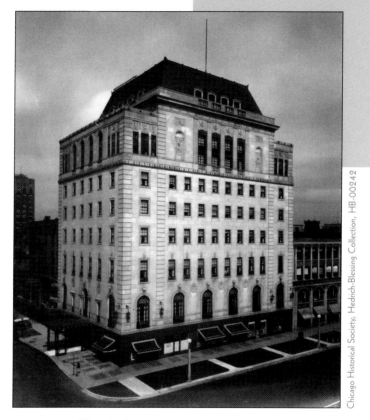

Women's Chicago Athletic Club, 626 North Michigan Avenue, 1926–1928, Philip B. Maher, architect. Featuring a mansard roof and elegant French-style windows, with masonry limestone walls, the club meshed perfectly with the design ideals recommended in Burnham's *Plan of Chicago*.

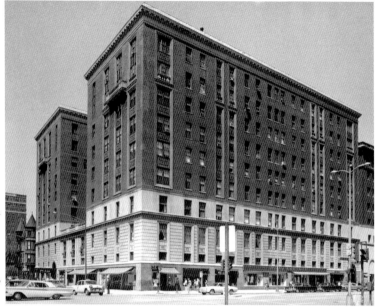

900 North Michigan Avenue Apartment Building, 1925–1927, Jarvis
Hunt, architect (demolished 1988). One of Chicago's earliest cooperative
apartment buildings, it included luxury apartments on the upper floors,
middle-class apartments on the lower floors, and shops at street level.

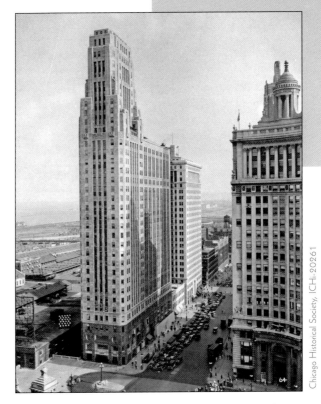

Chicago Historical Society, ICHi-20261

333 North Michigan Avenue Building, 1927–1928, Holabird and Root, architects, a design influenced by Eliel Saarinen's second-place entry in the Chicago Tribune Tower competition. The 333 North Michigan Avenue Building was important because it was the last of the four buildings constructed at the North Michigan Avenue Bridge and formed a southern terminus for the avenue when seen from the north.

Holabird and Root was commissioned to design several buildings on North Michigan Avenue following this model, including the Palmolive Building, whose design featured projecting and recessing planes complemented by a series of horizontal setbacks. The Michigan Square Building was designed as a forty-story structure but built only to the eighth floor. Located on the site of the present Marriott Hotel, this became one of the favorite shopping locations on North Michigan Avenue, featuring an elegant multilevel interior court with a great fountain in the center with a statue of Diana. The building was the ultimate in late-1920s Modernism, and foreshadowed the interior shopping malls of the 1980s and 1990s. Similar Modernist and Art Deco influences are evident in the Michigan-Chestnut Building, by Holabird and Root and the Michigan-Superior Building, by Andrew Rebori.

All these late-1920s buildings were built by corporations or speculators as corporate offices and for rental space; all had commercial shop space on the lower floors; all shared the same simplified stylistic motif; and all were built through credit financing, with banks and insurance companies providing mortgages. The expectation was large returns through tax write-offs and rising real estate values. Many of these expectations were shattered by the 1929 stock market crash; virtually all building on North Michigan Avenue ceased because of lack of demand for new office or commercial space. Many of the developers who had invested their time and money went bankrupt; others with more secure financial means struggled through.

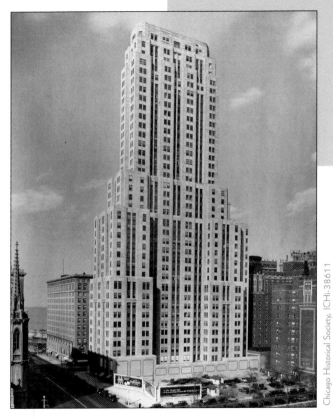

Chicago Historical Society, ICHi-38611

Palmolive Building (Landmark Residences), 919 North Michigan Avenue,
1927–1928, Holabird and Root, architects. This building features one of
the avenue's most elegant stepped-back profiles, with strong vertical lines.
It was converted from office use to condominium apartments in 2004.

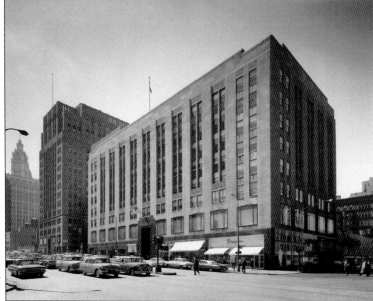

Michigan Square Building, 540 North Michigan Avenue, 1928–1929, Holabird and Root, architects (demolished 1978). This commercial block was designed to include a forty-story office tower; however, construction was never carried out because of the onset of the Depression.

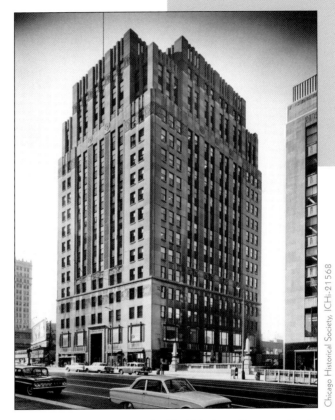

McGraw-Hill Building (Le Meridien Hotel/Nordstrom Department Store),
520 North Michigan Avenue, 1928–1929, Thielbar and Fugard, architects.
Preserved through the efforts of the Commission on Chicago Landmarks, this
building features classicized Art Deco detailing and a stepped-back top.

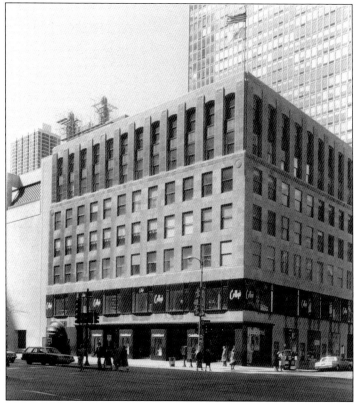

Michigan-Chestnut Building, 842 North Michigan Avenue, 1927–1928, Holabird and Root, architects (demolished 1992). Following the established formula of shop spaces on two floors with rental floors above, this building also featured artists' lofts with two-story-high studio spaces.

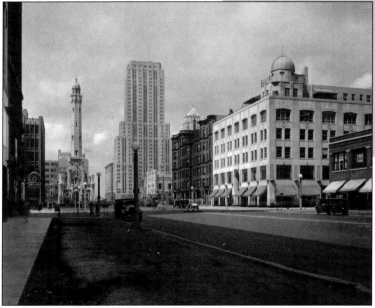

Michigan-Superior Building, 737 North Michigan Avenue, 1928–1929, Andrew Rebori, architect (demolished 1986). This building included artists' studios as well as a unique penthouse apartment for one of its owners.

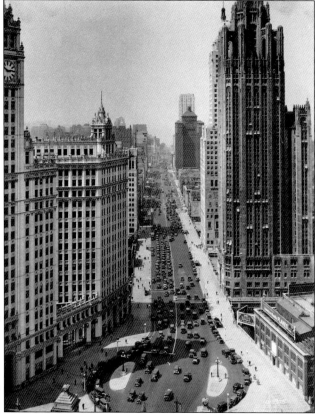

View of North Michigan Avenue looking north from the bridge plaza just prior to the Depression, which brought all real estate development to a halt. The Wrigley Building is visible on the left, the Tribune Tower on the right.

## REVITALIZATION EFFORTS FOR THE MAGNIFICENT MILE

Not until the mid-1950s did commercial activity on North Michigan Avenue begin picking up as new stores and shops opened and new office tenants rented additional space, fueled by improved economic conditions and a master plan and an advertising campaign initiated by real estate developer Arthur Rubloff in 1947. Known for building successful suburban shopping malls, Rubloff and his architect Holabird and Root proposed construction of new stores and office buildings, renovation of old ones, a more efficient traffic/parking system, landscaped promenades midblock, and taller office and apartment buildings at the back of each block.

Rubloff publicized his project in April 1947 with a promotional media blitz intended to sell the idea that North Michigan Avenue, which he nicknamed the Magnificent Mile, would once again be the city's preeminent commercial avenue. Rubloff asserted that the North Michigan Avenue development was something Chicago needed desperately to create a vast building boom.

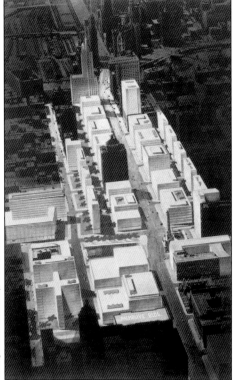

Rubloff Plan for the Magnificent Mile, 1947, Holabird and Root, architects, a master plan proposal prepared for real estate developer Arthur Rubloff. The rejuvenation of the North Michigan Avenue corridor set in place by Rubloff's efforts helped to pave the way for the building boom of the 1960s and 1970s, which firmly secured Michigan Avenue's place as the city's preeminent commercial boulevard.

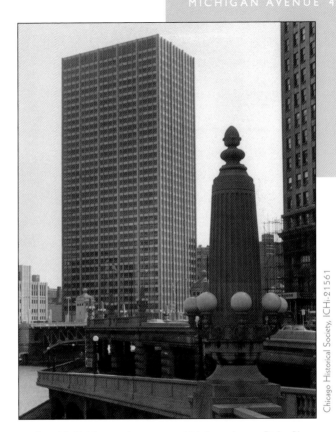

Chicago Historical Society, ICHi-21561

Equitable Building, northeast corner of Michigan Avenue Bridge Plaza, 1961–1965, Skidmore, Owings and Merrill, architects. The placement of this elegant Mies-inspired high-rise at the back of the site allowed for an unobstructed view of the Tribune Tower and made possible the development of Pioneer Court.

The avenue regained its preeminence as a shopping/office district after World War II, but building activity did not resume until the 1960s. The first major commission during this period was the Equitable Building, by Skidmore, Owings and Merrill, for the northeast corner of the Michigan Avenue bridge plaza. The building rises forty stories, with a metal-and-glass skin inspired by Chicago's best-known modern architect, Ludwig Mies van der Rohe.

The Miesian style is also apparent in the Illinois Center multitower complex east and south of the 333 North Michigan Avenue Building. The buildings' bronzed aluminum walls, squared-off tops, and stepped-back profile strongly contrast with the earlier building.

These projects, both centered around the bridge plaza, were closely followed by one near the avenue's north end that would dramatically change its scale and character: the John Hancock Building, designed in 1969 by Bruce Graham and Fazlur Khan of Skidmore, Owings and Merrill. This bold structure, which rises 100 stories in 1,127 feet, was one of the first to combine commercial, office, and residential uses on a very large scale. The exterior is imposing structurally, with dramatic diagonal bracing and a tapered profile that reflects the different floor areas required for office and residential uses. The inclusion of innovative diagonal cross braces—one of the first projects using computer-aided design—allowed for efficient use of the structural steel.

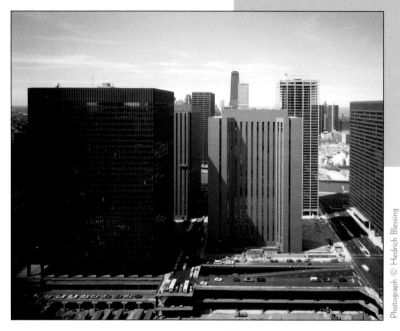

Illinois Center, 111 East Wacker Drive and 233 North Michigan
Avenue, 1968–1970, Office of Mies van der Rohe, architect. This
complex includes a series of office and hotel high-rises placed on a raised
open plaza, with interconnected commercial corridors just below.

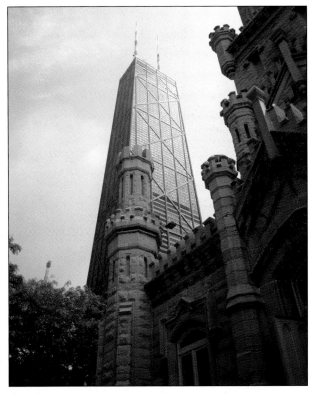

John Hancock Building, North Michigan Avenue between Chestnut Street and Delaware Place, 1965–1970; Skidmore, Owings and Merrill, architects, view of model. This 100-story building, the tallest on Michigan Avenue, covered only half its site, the front portion being given over to a sunken skating rink. It has been recently converted into a city square, with cascading steps and popular eateries.

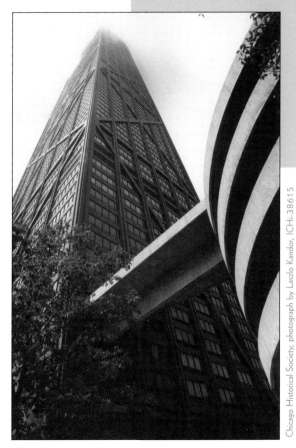

John Hancock Building. This dramatic perspective view shows the unique concrete spiral ramp leading to the tower's multistory parking garage.

Chicago Historical Society, photograph by Laszlo Kandor, ICHi-38615

Several high-rises constructed in the 1970s were designed with concrete frames rather than steel as the cost and structural capacity of concrete became increasingly competitive. These structures included the office building at 625 North Michigan Avenue, designed in 1971 by Meister and Volpe; and One Magnificent Mile, a fifty-seven-story tower with a sloped, glazed roof, completed in 1983. Located on a small angular lot at the northern end of Michigan Avenue and across from the Drake Hotel, One Magnificent Mile is a multiuse tower that combines commercial floors, offices, and luxury condominiums.

The most impressive concrete-framed building is Water Tower Place at 845 North Michigan Avenue, designed in 1976 by Loebl, Schlossman, and Hackl. It expanded the mixed-use concept of the Hancock Tower by adding a twelve-story commercial base featuring an indoor shopping mall centered around atrium space accommodating some 100 stores and shops. The principal tenants of the shopping mall are Marshall Field and Lord and Taylor; rising from its southeast corner is a sixty-two-story tower that houses a Ritz Carlton Hotel and luxury condominiums.

Water Tower Place established a new paradigm for the avenue, one that had been prefigured in the 1920s design of the unfinished Michigan Square Building. The combination of a commercial base with a high-rise tower proved ideal for maximizing return on investment and for dramatically increasing North Michigan Avenue's role as a tourist/shopping destination.

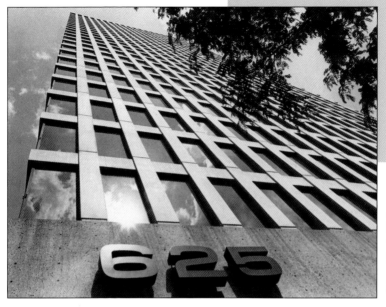

Chicago Historical Society,
ICHi-38616

625 North Michigan Avenue, 1971, Meister and Volpe, architects. This
office building, rising twenty-six stories, features a concrete frame with spe-
cially finished architectural concrete on the exterior, and corner windows.

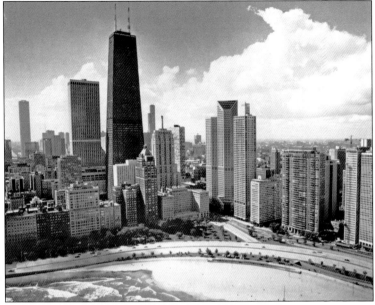

Aerial view looking south toward the Oak Street Beach, with One Magnificent Mile at center right, 940–980 North Michigan Avenue, 1983, Skidmore, Owings and Merrill. In center foreground are the Drake Hotel, Palmolive Building, John Hancock Tower, and Water Tower Place.

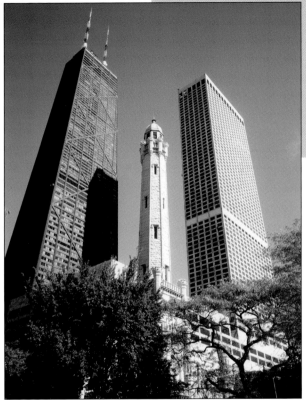

Water Tower Place, 845 North Michigan Avenue between Chestnut and Pearson Streets, 1974–1976 Loebl, Schlossman and Hackl, architects. This structure is a major departure from the neighboring Hancock Tower in that it has a concrete frame rather than a steel frame, and it is clad with white veined marble.

This new paradigm has greatly affected the avenue's urban character, however, as increasing demand for more commercial and residential space has meant the demolition of many of the buildings that gave the avenue its Parisian character in the 1920s. Some argue that the avenue has been ruined; others justify the changes by saying that since Chicago has always been known for innovative skyscraper architecture, let there be more skyscrapers. Former chairman of the Chicago Plan Commission, Miles L. Berger, admits distress over the loss of older buildings that gave North Michigan Avenue its distinctive character, but he asserts that Chicago is not Paris, a city that strictly limits building height and form. He feels that the city should continue to foster innovation in high-rise architecture. The Plan Commission has attempted to balance the interests of preservation and views to the lake while allowing the development necessary for the economic life and existence of the city.

The recent transformation of the avenue is evident in projects such as the Marriott Hotel, designed by Harry Weese in the late 1970s to replace the Michigan Square Building and atrium. Olympia Center at 737 North Michigan, with its four-story Neiman Marcus department store and sixty-three-story office and residential tower that faces Chicago Avenue, was designed by Skidmore, Owings and Merrill to replace Andrew Rebori's Michigan-Superior Building. The John Crerar Library, at the corner of North Michigan Avenue and Randolph Street, was demolished in 1983 for the construction of the

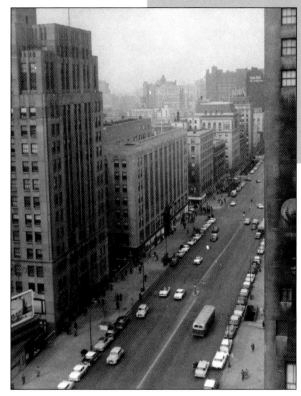

Chicago Historical Society, ICHi-19915

View of west side of North Michigan Avenue looking north from the Tribune Tower. McGraw-Hill Building is at the left, the Michigan Square Building in the center, then the Michigan-Ohio Building and the Erskine-Danforth Building. The latter three were demolished to make way for new buildings in the 1970s and 1990s, while the McGraw-Hill Building was renovated and incorporated into the Nordstrom department store.

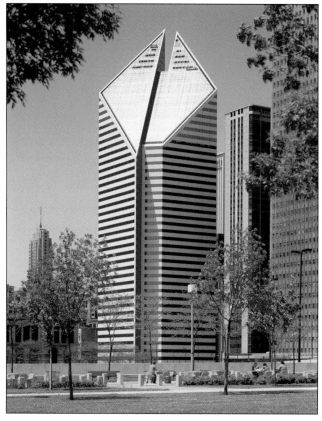

Associates Building (Smurfit-Stone Building), 150 North Michigan Avenue, 1983, A. Epstein and Sons, architect. A truncated top in the shape of a diamond is turned at a 45° angle to face Grant Park.

Associates Building by A. Epstein and Sons, with a unique diamond-shaped, truncated top.

The 900 North Michigan Avenue Building, at the northwest corner of Michigan and Delaware, once the site of Jarvis Hunt's Cooperative Apartment Building, was designed in 1983 by the New York firm of Kohn Pederson Fox. Its commercial base, housing Bloomingdale's Department store, is eight stories high, the same as the former building, honoring its traditional scale and enclosure and fronting the street. The limestone-clad hotel and condominium tower at the back of the site rise fifty-eight stories.

Other buildings followed the model of 900 North Michigan. City Place, at 676 North Michigan, features a shopping mall and the Omni Hotel. Designed by Loebl, Schlossman and Hackl in 1990, its tower is at the front of the site, perpendicular to rather than parallel with the street. In the next block, at 700 North Michigan Avenue, Chicago Place features Saks Fifth Avenue in a commercial block with eight levels of shopping, designed in a colorful Classical style by Skidmore, Owings and Merrill. A residential tower designed by Solomon, Cordwell, Buenz rises along its west side.

Several low-rise buildings have also been constructed recently, including the showy glass- and metal-clad commercial building between Ohio and

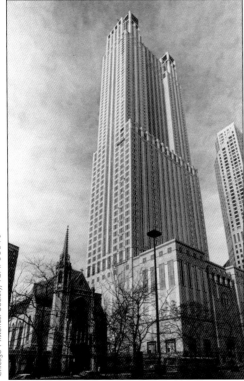

900 North Michigan Avenue, 1989, Kohn Pederson Fox, architects. The volume of the tower steps back at its intermediate point, reflecting the change from hotel to condominium floors, and the tower is capped by four gridded, translucent towers that are lit at night. Its tower features the traditional tripartite Chicago window, with an expression of the structural frame, with emphasis on verticality.

Ontario Streets containing Eddie Bauer, Ann Taylor, and the Grand Lux Café. This building replaced Alfred Alschuler's 1924 Michigan-Ohio Building and Philip Maher's 1928 Erskine-Danforth Building. The Plaza Escada, designed by Lucien Lagrange, originally planned as a thirty-story tower, replaced Holabird and Root's 1928–1929 Michigan-Chestnut Building.

A project more sensitive to the history of the avenue, and brought about largely through the efforts of the Commission on Chicago Landmarks, was the incorporation of the 1928–1929 McGraw-Hill Building into the massive Nordstrom department store at 570 North Michigan Avenue, built in 2001. It required the complete dismantling and restoration of the historic building's limestone facade.

One of the most elegant hotels constructed in Chicago in recent years is the Peninsula Hotel at 730–750 North Michigan. It is a long, narrow block, fourteen stories high, whose axis runs north and south between Superior Street and Chicago Avenue. Designed by Elkus/Manfredi in 1997–1998, it sits at the rear of the block, while four elegant shops front on North Michigan Avenue, each adhering to the quality design standards of the 1920s. Shops include the classically inspired Pottery Barn, designed by Hans Baldauf of BAR and BCV

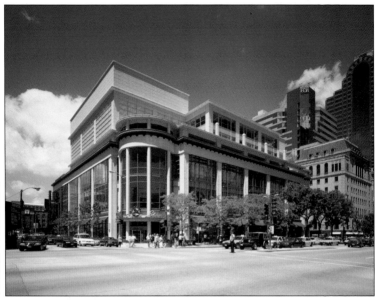

600 North Michigan Avenue, 1996, Beyer, Blinder, Belle, architects.
This transparent glass, metal, and terra-cotta commercial block replaced
the Michigan-Ohio and Erskine-Danforth buildings of the 1920s.

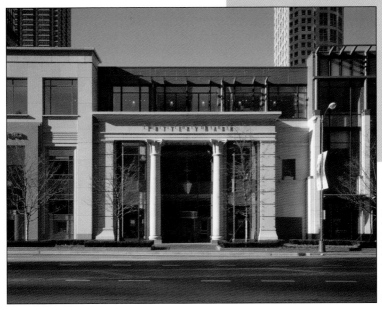

Photograph © Hedrich Blessing

Pottery Barn, 730–750 North Michigan Avenue, 1997, BAR and BCV Architects. Taking its cues from the avenue's 1920s Classical architecture, this facade features Corinthian columns of Mankado limestone and capitals fabricated from steel. It is one of four shops that line the avenue in front of the Peninsula Hotel, which extends at the back of the block between Superior Street and Chicago Avenue.

Architects, San Francisco; and the Elkus/Manfredi design of Tiffany's at the corner of North Michigan Avenue and Superior Street.

The economic vitality and architectural distinction of North Michigan Avenue are the results of numerous planning efforts, from Daniel Burnham and the NCBDA to Arthur Rubloff and Holabird and Root, all aimed at encouraging property owners and developers to restrict uses and to strive for quality in architectural design, materials, and construction. These factors, and the need to maximize return on investment, have long been hallmarks of North Michigan Avenue planning and development. Nowhere else in the city has there been such a concentration of financial resources combined with overarching ambition. Amid much concern for the urban character of the avenue as a whole, individual developers have willfully tried to outdo their neighbors and their predecessors. The ongoing planning proposals have helped guide the avenue's development and high standard for its architecture, but great diversity has also been present. The planners envisioned buildings of consistent height and character, yet the avenue has developed with dramatic extremes, from higher and higher towers to multistory rather than street-level shopping. This is the real expression of North Michigan Avenue, a place of change and innovation in urban design—in short, a microcosm of the American city.